THE POCKET

Miley Cyrus

Published in 2025
by Gemini Books
Part of Gemini Books Group

Based in Woodbridge and London

Marine House, Tide Mill Way,
Woodbridge, Suffolk IP12 1AP
United Kingdom
www.geminibooks.com

Text and Design © 2025 Gemini Books Group
Part of the Gemini Pockets series

Cover illustration by Natalie Foss

ISBN 978-1-78675-179-9

All rights reserved. No part of this publication may be reproduced in any form or by any means – electronic, mechanical, photocopying, recording or otherwise – or stored in any retrieval system of any nature without prior written permission from the copyright holders.

A CIP catalogue record for this book is available from the British Library.

Disclaimer: The book is a guidebook purely for information and entertainment purposes only. All trademarks, individual and company names, brand names, registered names, quotations, celebrity names, logos, dialogues and catchphrases used or cited in this book are the property of their respective owners. The publisher does not assume and hereby disclaims any liability to any party for any loss, damage or disruption caused by errors or omissions, whether such errors or omissions result from negligence, accident or any other cause. This book is an unofficial and unauthorized publication by Gemini Adult Books Ltd and has not been licensed, approved, sponsored or endorsed by Miley Cyrus or any other person or entity.

Printed in China

10 9 8 7 6 5 4 3 2 1

MIX
Paper | Supporting
responsible forestry
FSC® C020056

Images: Alamy: Alberto-G-R 40; Cinematic 7; PA Images 4. Getty: Kevin Mazur 8; Kevin Winter 104; Matt Cardy 76. Shutterstock Ltd: bioraven 64; Chalintra.B 88; CoCoArt_Ua 43; rawf8 53; Tartila 20; Tassia_K 28, 61, 91, 95, 109, 120; Tribalium 122.

THE POCKET

Miley Cyrus

G:

CONTENTS

Introduction 06

Chapter One
Teen Queen 08

Chapter Two
Wrecking Ball 40

Chapter Three
Pop Provocateur 76

Chapter Four
Flower Power 104

Miley Cyrus

Introduction

In the first decade of the 21st century, Miley Cyrus emerged as the brightest star on Disney, America's most-watched children's channel and the squeaky-clean home of many screen idols. As the leading light of the billion-dollar franchise *Hannah Montana*, she has said that playing Hannah gave her an identity crisis.

She soon chose to distance herself from her image as America's Sweetheart, and began systematically dismantling it with a wrecking ball and a revolving door of experimentation, both professionally and personally. In doing so, Miley blossomed into a *real* icon of popular culture. With her new nude, crude and full-on attitude, Miley became the ultimate pop provocateur, effortlessly switching her style and sound to suit her mood and fashions. Come 2013, she was the loud, proud voice of her generation... and the most talked-about artist on earth. A decade later, nothing changed, except *everything*, and she takes her loyal fans along for the joyride every step of the way.

Chapter One
Teen Queen

Miley Cyrus

Pink Isn't a Colour

Miley's fascination with flowers began at around the age of ten, when she started writing her first-ever songs for her all-girl rock band, Blue Roses. "Our first song was called 'Pink Isn't a Colour'", Miley revealed in *Rolling Stone* on 4 December 2020. Unfortunately, no lyrics from the songs survive. However, in 2018 Miley posted the line, "Pink isn't just a colour, it's an attitude", on Twitter – and it instantly became her new catchphrase.

Teen Queen

Independence Day

Every year Miley's 2009 smash hit 'Party in the USA' becomes hugely popular around the Fourth of July, and its accompanying weekend, when millions of Americans celebrate Independence Day.

In 2024, streams of the song surged by more than 200 per cent over the weekend, according to *Forbes* magazine, sending it back onto the Top 10 downloads charts with millions of additional streams.

Miley Cyrus

"I feel like the luckiest woman doing what I do. But being a pop star is kind of the dumbest shit of all time. I'm kind of embarrassed that I got paid to shake my ass in a teddy bear costume."

Miley, *Elle*, 21 September 2015

Alter Ego

At the age of 11, in 2004, Miley had grown bored of being an extra in her dad's TV show *Doc* (2001–04), or having small roles in movies such as Tim Burton's *Big Fish* (2003). She wanted her own show. At Disney's request – no doubt due to her father Billy Ray Cyrus's stardom – Miley sent a tape of her auditioning for the role of "Chloe Stewart" to the channel's executives for a show in development – *Hannah Montana*. However, Disney rejected Miley for being too young.

Miley would have to wait another two years, until 2006, before they changed their mind after Miley continued to send dozens of audition tapes. In the end, they agreed Miley was a star, awarded the role of *Hannah Montana* to her and even changed the name of her alter ego to Miley Stewart in honour of Miley's determination.

Miley Cyrus

Miles to Go

Aged just 18, Miley released her autobiography in 2009. Entitled *Miles to Go*, the book reveals to the reader the forces, events, mishaps and failures that shaped the young entertainer's life, filled with anecdotes and wisdom about fame and growing up a "teen queen".

When Miley announced its publication, she received much criticism. "People are like, 'You're 16, why would you write your life story?'," she told Marshall Heyman for *Teen Vogue* in April 2009. "But in the business I'm in, I have lived a life that some people who are in their 60s haven't lived. I've gone through a lot and seen a lot."

The book has sold more than 2 million copies.

Teen Queen

SMiley

Miley's millions of worldwide fans are known collectively as... Smilers.

Thankfully, that's a lot better fan name than a few others we could mention, especially Ed Sheeran's Sheerios, Ellie Goulding's Goulddiggers, Ariana Grande's Arianators, Justin Bieber's Beliebers, Lady Gaga's Little Monsters, Rihanna's Navy, Nicki Minaj's Barbies and, best of all, Lewis Capaldi's Big Fat Sexy Jungle Cats.

Miley Cyrus

Bright Minds

In 2020, as the COVID-19 pandemic surged around the globe, Miley decided to put her awesome voice to good use for her own Instagram talk show called *Bright Minded: Live with Miley*. Throughout its 20-episode run, Miley used her platform to provide a source of positivity and inspiration for her fans during a period of great uncertain, interviewing Demi Lovato, Selena Gomez, Amy Schumer, Rita Ora, Ellen DeGeneres, Alicia Keys and even Elton John.

In May 2020, she told *The Wall Street Journal:* "This show has evolved so deeply from trying to provide some escapism to actually the opposite: to not escaping, to diving into deeper involvement with our community."

Teen Queen

"I worked more when I was a kid than I'd ever allow myself to do now. I'm living out my rebellious teenage whatever now because I couldn't when I was younger."

Miley, *Elle*, 1 May 2014

Miley Cyrus

Twerking

2013's Word of the Year, according to the Oxford English Dictionary, was "twerking". All thanks to Miley, of course, and her iconic butt-shaking at the 2013 MTV Music Video Awards with Robin Thicke during their ridiculously raunchy performance of 'We Can't Stop/Blurred Lines'. The word's introduction into the dictionary was due to its visible increase in usage throughout 2013. Indeed, the question "What is twerking?" was the top trending "What is...?" search on Google for the whole year, thanks to Miley's awesome efforts.

FYI: Twerking is a dance that emerged from the hip-hop scene of New Orleans in 1990 known as "bounce". It basically involves a lot of booty vibrating!

Teen Queen

Happy Hippie

Miley's Happy Hippie Foundation is a philanthropic non-profit organization launched by the singer in 2014 as a response to the untimely – and unnecessary – death of Leelah Alcorn, a trans teen. Leelah left a suicide note that read: "Fix society. Please."

Miley listened and pioneered Happy Hippie to start addressing LGBTQ+ youth homelessness. Above all Miley's musical success, Happy Hippie is her greatest achievement.

"When I see kids wearing Happy Hippie T-shirts, that makes me feel so much more proud than if I had seven Grammys sitting on the wall," she said in an interview with Molly Lambert in *Elle*, 11 July 2019.

Miley Cyrus

The Voice

If there's anyone in the world who can judge the qualities of another person's singing voice it's Miley, an artist whose voice is as distinct as it is powerful. In 2016, for the 11th season of the reality singing competition show, NBC's *The Voice*, Miley was invited to be a coach, replacing Pharrell Williams and Christina Aguilera. Miley didn't win with her singers, but her appearance on the famous Red Chair certainly helped increase ratings – the season was a surefire hit!

Teen Queen

> "The minute I had sex for the first time, I was like, 'I can't put the fucking wig on again!' It got weird. It felt ridiculous. I was grown up."

Miley, *Teen Vogue*, 1 November 2023

Miley Cyrus

Voice Transformation

In recent years, social media has been abuzz with several viral videos of Miley's supposed "voice transformation" from her once famous light Southern drawl to a full-on deep, raspy "smoker's voice". On the *Joe Rogan Experience* in September 2020, Miley explained the causes behind the change. "I had Reinke's oedema*, which is an abuse of the voice. This is for people that talk way too fucking much!" Miley would also later explain in an interview on *The Howard Stern Show*, 4 December 2020, that when she lost her house in Malibu, due to the devastating wildfires, the trauma really affected her voice.

*Reinke's oedema is a condition that occurs where the surface of the vocal folds fill with fluid, becoming swollen and distended. It's common in smokers and predominantly females.

Teen Queen

The Stages of Miley

Since her first artistic transformation with the release of *Can't Be Tamed*, Miley has earned the label "pop chameleon" for her continual reinventions and rebranding. Her fans have praised her versatility and innovation. To date, Miley has had (at least!) five creative phases:

1. *Teen Queen* (2006–09)
Disney's de facto fairytale princess
and star of *Hannah Montana*

2. *Young Adult* (2009–12)
Flirted with an edgier, provocative sound,
as heard on *Can't Be Tamed*

3. *Wild Child* (2013–16)
Full-on heavy rebellion filled with controversial
performances and photoshoots,
and experimental production

4. *Mature Miley* (2017–20)
Introspective, calm and toned-down musically with
elements of acoustic folk, a grown-up Miley

5. *Independent Woman* (2021–24)
Powerful philanthropist and businesswoman, brand
icon and deeper meanings in her music

Miley Cyrus

'Flowers' for a Grammy

In February 2024, Miley won her first-ever Grammy Awards for 'Flowers'. It won Record of the Year and Song of the Year. Following the wins, the album *Endless Summer Vacation* increased sales by more than 100 per cent, according to Forbes. It also won Best International Song at the Brit Awards in 2024.

Teen Queen

> "This award is amazing, but I really hope it doesn't change anything because my life was beautiful yesterday. Not everyone in the world will get a Grammy but everyone in this world is spectacular so please don't think that this is important."

Miley, on accepting her Grammy for 'Flowers', *Forbes*, 14 February 2024

Miley Cyrus

"I tried to go to therapy a few times. They treated me like I was everyone else who sits on the couch. They'd be like, 'Well, you probably feel paranoid because you're smoking weed.' And I reply, 'No, I feel paranoid because people are putting little drones in my backyard.'

…One time I was naked on top of a fake horse in my garden when a drone showed up. And I'm like, 'Honestly, I couldn't have asked for a better time.' At least I wasn't sitting there drinking coffee, being boring!"

Miley, *Elle*, 11 July 2019

Hannah Montana

Three years after Miley became a global teen superstar on Disney's *Hannah Montana*, the character's very first feature film was greenlit and, on 10 April 2009, the *Hannah Montana – The Movie* was released!

The film was a huge success, making $170 million, and debuted at the No. 1 spot at the US box office. The movie's soundtrack was a huge success too, and features the hit songs 'The Climb', 'Crazier' (written and performed by Taylor Swift) and 'Butterfly Fly Away', a duet she sings with her father, Billy Ray. The movie did so well it even earned a sequel, released in May 2011.

Miley Cyrus

Essential Album: *Meet Miley Cyrus*

Miley's solo singing career started properly in June 2007 with the release of her debut album, the pop-rocker *Meet Miley Cyrus*. It's no ordinary debut: it was a double-disc release containing two albums. The first disc was the soundtrack to the second season of *Hannah Montana* and the second was Miley's debut studio album featuring eight songs.

1. 'See You Again'
2. 'East Northumberland High'
3. 'Let's Dance'
4. 'G.N.O. (Girl's Night Out)'
5. 'Right Here'
6. 'As I Am'
7. 'Start All Over'
8. 'Clear'
9. 'Good and Broken'
10. 'I Miss You'

Teen Queen

'Party in the USA'

Miley arrived as a serious professional musician with her EP *The Time of Our Lives*, released in August 2009. The EP's success was defined by its lead single's worldwide triumph. 'Party in the USA' debut at No. 2 in the Billboard Hot 100 chart and went on to become one of the best-selling singles of all time in America, selling more than 7 million copies that year.

In 2020, while appearing on *Jimmy Kimmel Live!*, Miley was awarded an RIAA Diamond certification for the song, a prestigious plaque given for more than 10 million copies sold – one of just 100 songs ever to reach that standard.*

*Naturally, the contrarian Miley hates the song! In May 2019, she posted on her Instagram Stories and said: "I hate it, but for some reason, the people love it."

Miley Cyrus

Psychedelia

The least understood – and loved – of all Miley's albums is her fifth studio release, 2015's *Miley Cyrus & Her Dead Petz*. This experimental, psychedelic record was written and recorded as Miley was emerging out of her "wild and crazy" era.

Produced in collaboration with alternative pop band The Flaming Lips, the album is a stark contrast to Miley's other albums and highly personal.

"The Flaming Lips have had me on this journey that's greater than anything I've been on. It's really deep," Miley told *Rolling Stone* on 9 May 2014. Wayne Coyne, The Flaming Lips' singer, saw Miley as a kindred spirit. "We're so much alike in believing art is supposed to be fun. She's just a freak!" he said.

Teen Queen

"Don't let this blond hair fool you. I'm the one signing my checks."

Miley, on being the boss of her brand,
Elle, 11 July 2019

Miley Cyrus

Record Breaker

In her near 20-year career, Miley has swung a wrecking ball into many world records. She currently holds eight Guinness World Records – a world record in of itself!*

Five of the seven records are for the track 'Flowers'. It is Spotify's most streamed song in one week, one year (2023) and of all time. It is also the fastest song on Spotify to reach 100 million streams and one billion streams. So far these records are yet to be beaten.

In addition to these titles, Miley is also the Most Charted Teenager, the Highest Earning Child Actor and the artist with the Most Entries Simultaneously in the US Top 100 in One Week.

*Probably.

Teen Queen

One of the GOATs

In 2023, Billboard, America's chart operator, ranked Miley as the third-greatest female artist in the year-end results of the Hot 100 Artists.

1. SZA
2. Taylor Swift
3. Miley Cyrus
4. Olivia Rodrigo
5. Ice Spice
6. Nicki Minaj
7. Selena Gomez
8. Lainey Wilson
9. Doja Cat
10. Beyoncé

Miley Cyrus

The world's *biggest-selling artists of all time*, according to the RIAA (measured in millions of digital sales) in 2024 are:

166.5 – Rihanna
137.5 – Taylor Swift
114.5 – Beyoncé
112 – Katy Perry
82.5 – Lady Gaga
73.5 – Ariana Grande
60 – Mariah Carey
60 – Miley Cyrus
58 – Cardi B
57 – Britney Spears

This makes Miley not only one of the most successful artists of the 2010s, but also of all time. The question is: how much bigger can she get?

Teen Queen

Wonder World

Miley's first world tour, the Wonder World Tour, of 2009, was the first series of shows where Miley no longer performed material as the Disney character Hannah Montana. Fifty-six shows in total, the tour became known as the first of several moments where Miley began to transition from child entertainer into a professional, serious and often edgy musical artist. The tour was a critical and commercial success, breaking audience attendance records at arenas all over the world, and grossing more than $67 million. Unbelievable, considering Miley was still just 17 years old.

Miley Cyrus

24 March 2006

The date Miley's life changed. It was the first episode air date of *Hannah Montana*, Miley's first starring role, and her first appearance in the role of Miley Stewart, a regular 14-year-old middle school student who also has a secret identity – famous pop singer Hannah Montana! During its four-season run, until 2011, Hannah Montana remained the Disney Channel's most commercially successful franchise with episodes regularly receiving 10 million* viewers.

*The most-watched episode, with nearly 11 million viewers, was 'Me and Mr. Jonas and Mr. Jonas and Mr. Jonas' – the one where Miley meets special guest stars, the Jonas Brothers (and falls in love with Nick).

Teen Queen

The Debut Single

Met with critical and commercial acclaim when it was first released on 29 December 2007, Miley's debut single, the dance-rock anthem, 'See You Again' was also one of the first songs to be credited to Miley as songwriter. Naturally, Miley expressed a dislike of it years later. "I'm not sure about this song," she told Walmart in an interview on 6 December 2009. "I don't really like it that much. It's just OK." Fans disagreed – and sent the track to No. 10 on the Billboard Hot 100 charts, selling more than 3 million copies. Miley had arrived.

Miley Cyrus

"I was creating attention for myself because I was dividing myself from a character I had played."

Miley, on her wild and rebellious phase after ending *Hannah Montana*, *Rolling Stone*, 18 May 2023

Teen Queen

Breaking the Internet

Miley's worldwide super-smash hit 'Flowers' – her biggest song to date – broke the Internet when it was released in January 2023. By the end of the year it became the best-selling global single of 2023 amassing a massive 2.7 billion streams, according to the International Federation of the Phonographic Industry (IFPI).

For those that are counting, that's more than 7 million streams a day – *every day of the year*!

Chapter Two
Wrecking Ball

Miley Cyrus

"I've been doing this for 20 years, and this is my first time actually being taken seriously at the Grammys? I've had a hard time figuring out what the measurement is there, because if we want to talk stats and numbers, then where the fuck was I? And if you want to talk, like, impact on culture, then where the fuck was I? This is not about arrogance. I am proud of myself."

Miley, on her Grammy win, *W* magazine, 3 June 2024

Wrecking Ball

Going Acoustic

On 28 January 2014, Miley recorded a sublimely well-received performance of acoustic versions of her hits for MTV's iconic *Unplugged* series. Miley played a selection of songs from her recently released *Bangerz* album, as well as her definitive 'Jolene' by Dolly Parton. One of Miley's biggest inspirations, Madonna, also turned up to perform a duet. She mashed her 'Don't Tell Me' with Miley's 'We Can't Stop'. "That was pretty fucking cool," Miley told the audience after the duet. "I get to perform with Madonna in bedazzled cowboy boots. I can't really complain about anything." It goes without saying, the concert became the highest-rated *MTV Unplugged* ever, with more than 1.7 million live streams.

Miley Cyrus

Glastonbury

Miley's debut Glastonbury festival performance in 2019 is now considered the stuff of legend. The show included special guest appearances by Mark Ronson and Lil Nas X, and featured covers by artists as diverse as Amy Winehouse, Led Zeppelin, Metallica, Dolly Parton and Nine Inch Nails, as well as a "cover" by her other alter ego, Ashley O (Miley's character from her groundbreaking *Black Mirror* episode, 2019).

Wrecking Ball

Glasto Setlist

'**Nothing Breaks Like a Heart**' (with Mark Ronson)
'**Back to Black**' (Amy Winehouse cover,
with Mark Ronson)
'**Mother's Daughter**'
'**Black Dog**' (Led Zeppelin cover)
'**Unholy**'
'**Nothing Else Matters**' (Metallica cover)
'**D.R.E.A.M.**'
'**Cattitude**'
'**We Can't Stop**'
'**The Most**'
'**Party Up the Street**'
'**Malibu**'
'**Jolene**' (Dolly Parton cover)
'**Party in the USA**'
'**Old Town Road**' (Lil Nas X cover, with Lil Nas X
and Billy Ray Cyrus)
'**Panini**' (Lil Nas X cover, with Lil Nas X)
'**On a Roll**' (as Ashley O)
'**Head Like a Hole**' (Nine Inch Nails cover)
'**Wrecking Ball**'

Miley Cyrus

The 27 Club

In 2019, after three years of "being wild", the 'Can't Be Tamed' singer decided to get sober. Her desire to quit her excessive vices was down to one simple fact: she didn't want to join the 27 Club, a cultural phenomenon by which a growing list of celebrated artists died at age 27, including celebrities such as Amy Winehouse, Jimi Hendrix, Jim Morrison, Kurt Cobain, Brian Jones, and many more.

Wrecking Ball

"Twenty-seven was a year that I really had to protect myself. That actually really made me want to get sober, because we've lost so many icons at 27. Some of the artists couldn't handle their own power, their own energy. I, no matter what, was born with that."

Billboard, 24 November 2020

Miley Cyrus

In *Time*

In 2014, Miley was chosen by *Time* as one of the magazine's prestigious Persons of the Year and as one of their 100 most influential people in the world. To acknowledge this astonishing accomplishment for someone so young, Miley's "fairy godmother" Dolly Parton paid tribute:

"If I didn't know how smart and talented Miley is, I might worry about her. But I've watched her grow up. So I don't. She knows what she's doing. The girl can write. The girl can sing. The girl is smart. I did it my way, so why can't she do it her way?"

Wrecking Ball

Social Media Hurts Your Brain

Miley is one of the most followed people in the world on social media. She has more than 215 million followers on Instagram – the entire population of Brazil! – though she doesn't operate the account or post personally.

In fact, Miley has been vocal about her distrust of social media in recent years, claiming that it is worse for your health than smoking. "You know what hurts your brain? Googling yourself," she told *Sunday Night* host Chris Bath in August 2014. "You know what hurts your brain? Instagram. You know what hurts your brain? Reading comments on Facebook."

Miley Cyrus

Dancing Queen

According to her autobiography, 2009's *Miles to Go*, Miley's hope of fulfilling her destiny to become a world-famous entertainer started following a performance of Abba's *Mamma Mia!* at the Royal Alexandra Theatre in Toronto, Canada, between May and September 2000. Miley would have been eight years old. Miley caught the show with her dad, Billy Ray, and afterwards grabbed his arm and said, "This is what I want to do, daddy. I want to be an actress!" By the end of the decade, Miley's wish upon a star had come true.

Wrecking Ball

"I wrote 'Flowers' in a really different way. The chorus was originally: 'I can buy myself flowers, write my name in the sand, but I *can't* love me better than you can.' It used to be more, like, 1950s. The song is a little fake it till you make it… which I'm a big fan of."

Miley, *Vogue*, 18 May 2023

Miley Cyrus

And Before Hannah, There Was Lizzie

Miley's desire to be the next *Lizzie McGuire* – the 2001–03 hit Disney show – stemmed from Miley's obsession with the actress who portrayed Lizzie – Hilary Duff. During a 2020 interview on Miley's Instagram Live show *Bright Minded*, Miley admitted that it was through watching Hilary that success inspired her 11-year-old self to persistently send Disney audition tapes for *Hannah Montana*.

"The only reason I wanted to be Hannah was so I could do whatever you did," Miley told Duff. "I don't think I gave a shit about being an actress or a singer. I just wanted to copy you no matter what."

Wrecking Ball

"When I did 'Wrecking Ball' nobody saw my pain of me looking directly into the camera, breaking the wall, crying, reaching out. Everyone just remembers me getting naked."

Miley, on the 'Wrecking Ball' video, *Rolling Stone*, 4 December 2020

Miley Cyrus

Baring All

In 2008, after the rapid rise of *Hannah Montana* as one of the Disney Channel's highest-rated series of all time, paparazzi photos of the 14-year-old Miley were being sold for as much as $2,000 a picture, according to the *Los Angeles Times* on 28 May 2008.

This dark obsession of selling photos of Miley culminated in her personal Gmail account being hacked in 2011 and revealing images were sold online. The hacker, who worked out Miley's password, was later sentenced to three years of probation for computer crimes. This sleazy interest in Miley's body was a motivating factor for her to bare all on her own terms – in high-end fashion magazines – effectively making hackers and paps redundant.

Wrecking Ball

"People get told that it's a bad thing to change. People will tell me, 'You've changed.' And that's supposed to be derogatory. But you are supposed to change all the time."

Miley, *Harper's Bazaar*, 13 July 2017

Miley Cyrus

The Numbers Don't Lie

As of July 2024, Miley has sold more than 20 million albums, across eight studio albums and sold more than 55 million singles, across 42 single releases, worldwide.

Today, it is estimated that Miley's net worth is valued at around $160 million, according to *Parade* (4 February 2024), thanks in part to her album sales, her brand deals (she's the face of Dolce and Gabbana) and world tours. Her debut tour, Wonder World, in 2009, netted her $15 million in profit.

Wrecking Ball

A Changing Self-image

After *Hannah Montana* ended in 2011, after four seasons, Miley admitted to finding herself dazed and confused about who she was... and wasn't. In 2020, she was a guest on Sirius FM's *The Howard Stern Show* and revealed her identity struggle.

"Hannah Montana's premise was that when I had my normal hair and looked like myself, no one gave a shit about me. And then when I got all dolled up and put a wig on, all of a sudden, I'm being chased by people chasing my tour bus. So, that's a lot to put on a kid – to go, 'When you're yourself, no one gives a fuck.'"

Following the end of *Hannah Montana*, Miley went on a voyage of self-discovery, which resulted in 2013's *Bangerz* album, her biggest-selling album to date.

Miley Cyrus

> "I felt it was her destiny to bring hope to the world."

Billy Ray Cyrus, on Miley's birth-registered name,
The Ellen DeGeneres Show, 2007

Destiny

Destiny Hope Cyrus legally changed her name to Miley Ray Cyrus in 2008. Uncomfortable with the pressure of living up to her name (Miley claimed in an interview with David Letterman that Destiny Hope was "too big a shoe to fill"), she changed her name to Miley because of her childhood nickname, Smiley, which was soon shortened to Miley.

Miley Cyrus

Love at First Sight

Miley's first love (other than her legion of pets, of course) was the singer Nick Jonas, one-third of the hugely popular boy band, the Jonas Brothers. The pair met a charity event in 2006 when they were 13 years old. In the media, the relationship was referred to as Niley!

"We became boyfriend and girlfriend the day we met," Miley told *Seventeen* in January 2008. "For two years he was basically my 24/7." After the teenage relationship ended, Miley was heartbroken and claimed she "bawled her eyes out for a month straight."

Wrecking Ball

Most Popular Singles

Miley is one of the most viewed female artists on YouTube. She currently has amassed more than nine billion views for her official music videos. These are her Top 10 most popular, as of July 2024.*

'Wrecking Ball'
'Party in the USA'
'We Can't Stop'
'Flowers'
'Malibu'
'The Climb'
'Jolene' (Backyard Session)
'7 Things'
'Don't Call Me Angel'
'Midnight Sky'

*According to Spotify, Miley has more than 18 billion total listens on the streaming platform.

Miley Cyrus

Cowboy Companions

Following hot on the heels of her 2023 worldwide phenomenon with 'Flowers', in April 2024 Miley repeated the trick with 'II Most Wanted', a Top 10 collaboration with long-time buddy, Beyoncé, taken from her game-changing country album, *Cowboy Carter*. "I wrote that song two and a half years ago," Miley told *W* magazine in June 2024. "So when Beyoncé reached out to me, I thought of it right away because it really encompasses our relationship. I told her, "We don't have to get country; *we are* country. Getting to write a song, not just sing, for Beyoncé was a dream come true."

Casting for Disney

In late 2005, Miley was cast (finally!) as Hannah Montana after two years of persistently sending audition tapes to Gary Marsh, the Executive Vice President of Disney. Despite initially being rejected for the role for being too young and inexperienced, Marsh awarded Miley the role after seeing more than 1,000 actresses audition. Miley was ultimately chosen, according to Marsh, due to her energetic and lively performance together with the fact that she was the perfect combination of Hilary Duff and Shania Twain.

Miley Cyrus

Jolene

Miley's favourite song of all time is, of course, Dolly Parton's 'Jolene'. It's Miley's most performed cover when she is on tour. The song was originally released in 1973 and, amazingly, written the *same week* that Parton wrote her other biggest hit, 'I Will Always Love You'.

Wrecking Ball

"The reason I think the song 'Jolene' has resonated with so many people for so long is because most of us have actually had a Jolene in our lives at one time or another. But more importantly, we've all felt insecure about something. We've all felt like we might lose someone we love to someone else because we're not good enough, and that's what this song's really about."

Dolly Parton, *Dolly Parton's Heartstrings*, 22 November 2019

Miley Cyrus

"I was told for so long what a girl is supposed to be from being on *Hannah Montana*. I was made to look like someone that I wasn't, which probably caused some body dysmorphia because I had been made pretty every day for so long. And then when I wasn't on that show, it was like, 'Who the fuck am I?'"

Miley, *Teen Vogue*, 1 November 2023

Wrecking Ball

> "If you think dancing on top of an ice-cream cart with a pole is bad, then go check what 90 per cent of the high schoolers are really up to."

Miley, on her notorious 'Party in the USA' "pole dancing" performance at the Teen Choice Awards 2009, *Parade*, 21 March 2010

Miley Cyrus

Smokin' Miley

Eighteen-year-old Miley hit the headlines in 2010 (again) – while she was still starring in Disney's *Hannah Montana* – when leaked video footage was released on the Internet of her smoking salvia, a hallucinogenic herb. It was described as "the bong hit seen around the world". As a role model for a pre-teen show, Miley was quick to apologize. "I'm not perfect. I made a mistake. I'm disappointed in myself for disappointing my fans," she posted on Twitter.

Wrecking Ball

"One time I went backstage at Disneyland, and Peter Pan was smoking a cigarette. And I was like, 'That's me. That's the kind of dreams I'm crushing.' That's how everyone felt with the bong video, but I'm not a Disney mascot. I'm a person."

Miley, *Elle*, 11 July 2019

Miley Cyrus

Changing Styles

To show the world that Miley was no longer to be associated with famous alter ego, Hannah Montana – and the wig she was made to wear to distinguish herself from that character – in 2012, Miley infamously took inspiration from Britney Spears' famous head-shaving and cut her long luscious brown locks into a peroxide-blonde pixie cut.

Taking to Twitter to explain her actions, Miley said that with the hair gone she had "never felt more herself".

Songwriting Stats

At the heart of Miley's musical success is the little-observed truth that she is an accomplished songwriter, responsible for soundtracking the lives of many of her generation. While she is not credited with her biggest earliest hits – 'Party in the USA' and 'Wrecking Ball' – Miley has written more than 90 of her 120 recorded songs. On her 2023 album *Endless Summer Vacation*, Miley is credited as lead songwriter on all 12 songs.

"No matter how long what I'm doing here lasts, I want to be a songwriter for the rest of my life. I love it. It's my escape. More than anything, I'm a writer," she told Cortney Harding, in an interview with *Billboard* in June 2008.

Miley Cyrus

"The more that you love your own decisions, the less you need other people to love them."

Miley, *CBS Sunday Morning with Anthony Mason*, 29 October 2017

On Touring

Unlike her peers Taylor Swift, Ariana Grande and Dua Lipa, Miley no longer schedules world tours as part of her album promotional campaigns. Her Attention Tour in 2022 was her last. In May 2023, the singer posted a heartfelt message on Instagram to announce the news:

"Even if I don't see my fans face to face every night at a concert, my fans are felt deeply in my heart. I'm constantly creating and innovating new ways that I can stay connected to the audience I love without sacrificing my own essentials. Performing for you has been some of the best days of my life. This has nothing to do with a lack of appreciation for the fans and everything to do with I simply don't want to get ready in a locker room. Which is the reality of life on the road. I just don't want to sleep on a moving bus. It isn't what's best for me right now."

Miley Cyrus

Heart Pain

In Miley's 2009 autobiography *Miles to Go,* Miley revealed that she has a non-dangerous heart condition known as tachycardia.

One of the symptoms of this condition is an increased heartbeat, often with more than 100 beats per minute, even when at rest. "It won't hurt me, but it does bother me," Miley said. "There is never a time onstage when I'm not thinking about my heart."

Wrecking Ball

"I was attracted to girls way before I ever was attracted to guys. When I was 11 years old, I used to think that Minnie Mouse was super fucking hot, which is so good I ended up on Disney, so my chances with Minnie went up by like 100."

Miley, on her gender fluidity, Barstool Sports' Call Her Daddy podcast, 13 August 2020

Chapter Three
Pop Provocateur

Miley Cyrus

Fairy Godmother

Miley's godmother is the country music superstar, Dolly Parton. The legend Parton became close with Miley's father, Billy Ray, when he toured with her while promoting his 1992 single, 'Achy Breaky Heart'. "We just got to be good friends because he's a Kentucky boy, I'm from Tennessee," Parton revealed on Sirius FM's *The Howard Stern Show* in 2023. "And then when Miley came along, I said, 'She's got to be my fairy goddaughter.'"

Dolly even made an appearance on *Hannah Montana* as Miley Stewart's fairy godmother in an episode called 'Good Golly Miss Dolly' (Season 1, episode 16).

Miley adores Dolly too: "I watch people like Dolly. Dolly knows what she is. She's smart. She's not just a blonde with big titties – she is a genius under there," Miley told *Rolling Stone* in 2013.

Pop Provocateur

"I don't actually walk around all day twerking with my tongue out dressed as a teddy bear."

Miley, *BBC Newsbeat*, 12 November 2013

Miley Cyrus

World on Fire

In November, Miley's home in Malibu, California, the one she shared with her then-husband, Liam Hemsworth, burned to the ground during the Woolsey wildfires of November 2018. The fire destroyed 1,643 structures, killed three people, and prompted the evacuation of more than 295,000 people. Along with the house and all her possessions, Miley also lost all her beloved pets: two pigs, two horses, four cats and seven dogs.

Pop Provocateur

"Your mind can be your army or your enemy – and you have to learn how to control that."

Miley, on mental health, *Cosmopolitan*, 26 October 2013

Miley Cyrus

Photo Fame

In June 2008, at the height of her earliest *Hannah Montana* stardom, Miley was captured by famed photographer Annie Leibovitz for a cover feature in *Vanity Fair*, a major milestone in any celebrity's career. Unfortunately, for then-15-year-old, the photo – which contained the singer covered, but topless in a "provocative" pose – caused an immediate controversy and backlash among the predominantly conservative parents of her pre-teen fans. Miley was made to apologize, claiming "I never intended for any of this to happen, and I am truly sorry if I have disappointed anyone."

In 2018, Miley retracted her apology on Twitter and posted the words: "I'M NOT SORRY" adding "FUCK YOU".

Pop Provocateur

Family Business

Miley might be the most famous member of the Cyrus family these days but she has not one, not two, but three famous siblings too. Miley's oldest sister Brandi is an actress and DJ, and her oldest brother, Trace, is the lead singer of the pop-punk band Metro Station (they had a hit in 2010 called 'Shake It'). Miley's younger brother Braison is a musician too, and released his debut album *Javelina* in 2021. And her youngest sister, Noah, is a successful musician too – and was even nominated for Best New Artist at the 63rd Annual Grammy Awards in 2021.

Miley Cyrus

Breaking the Internet

Miley's shedding of her "teen queen" brand once and for all in October 2013 – a month after the release of *Bangerz* – came when she posed in multiple fully nude and controversial shots for *Candy* magazine, with images taken by famous fashion photographer Terry Richardson. It's safe to say these photos broke the Internet.

It's little wonder that *Bangerz* went to No. 1 worldwide and sold 7 million copies – everyone was talking about Miley. Indeed, in 2013, Miley was Google's most searched person, according to their annual Zeitgeist Report, followed by Drake, Kim Kardashian, Justin Bieber and Beyoncé!

Pop Provocateur

"I have such a healthy and sexy relationship with recklessness right now. I can say yes to anything. It would take something really fucking crazy for me to say no."

Miley, *Interview*, 4 June 2021

Miley Cyrus

To Be...
or Not To Be

When actor Liam Hemsworth and Miley met on the set of *The Last Song* in 2009, the pair fell in love almost at first sight. They dated on and off for nine years. In December 2018, they married in secret. On the day, Miley announced her newlywed news to her millions of fans with an Instagram post that read "This is probably our one millionth kiss," accompanied by a photo of the happy couple canoodling.

Sadly, the pair split after eight months, in August 2019, and were officially divorced in 2020.

Pop Provocateur

"Getting married, for me, was one last attempt to save myself."

Miley, *Rolling Stone*, 4 December 2020

Miley Cyrus

"It's kinda crazy that I'll always be known for licking a sledge hammer!"

Miley, on the 'Wrecking Ball' music video, *The Cooper Lawrence Show*, 17 May 2017

Pop Provocateur

Break Me

On 9 September 2013, Miley Cyrus broke the Internet. Again. For the sixth time. *That year*. It was the date of the smash-hit music video premiere for 'Wrecking Ball', the lead single from Miley's *Bangerz* album. After watching it, it was all the whole world talked about for weeks. If you haven't seen it (of course you have), it features Miley swinging naked on a wrecking ball and licking a sledgehammer before destroying a wall. Unsurprisingly, it's her most watched video with 1.2 billion views on YouTube, as of July 2024.

Miley Cyrus

Essential Album:
Can't Be Tamed

Miley's third album *Can't Be Tamed*, released in 2010, is undoubtedly her first classic. It's the record that shows Miley's desperation to distance herself from her Disney Princess persona. Indeed, in the title track's lyrics, Miley makes it apparent: "For those who don't know me, I can get a bit crazy!" Discussing the album, Miley told *MTV News* in 2014 that it was her "last teen pop record, because in a few years, as I grow up, so will my fans, and I won't have to focus on that as much, and I'll be able to have more of the sound of music that I'm into." And, indeed, her next album, *Bangerz*, was a shift, focusing on a rawer, R&B sound.

Pop Provocateur

'Liberty Walk'
'Who Owns My Heart'
'Can't Be Tamed'
'Every Rose Has Its Thorn'
'Two More Lonely People'
'Forgiveness and Love'
'Permanent December'
'Stay'
'Scars'
'Take Me Along'
'Robot'
'My Heart Beats for Love'

Miley Cyrus

"I know what I'm doing.
When I'm dressed in
that teddy bear suit,
I think that's funny.
When I'm in that
teddy bear suit,
I'm like a creepy, sexy baby.
I know I'm shocking you."

Miley, *Rolling Stone*, 27 September 2013

Pop Provocateur

Big Trouble

With the arrival of 2013's MTV European Music Awards in November, it was clear that Miley was out to cause some trouble. With *Bangerz* riding the top spot in the US charts, Miley took to the MTV stage in Amsterdam and – drum roll! – lit up a joint* in front of 20,000 fans moments before she accepted the award for Best Music Video for 'Wrecking Ball'. "You know, I couldn't fit this award in my bag but I did find… this,'" she told the audience as she held up a spliff.

*At the time, smoking marijuana in Amsterdam in public was not illegal.

Miley Cyrus

Twerktastic

With her new peroxide blonde pixie hair, a giant foam finger and a nude latex bra and panty set, Miley Cyrus stepped on stage to perform 'We Can't Stop/Blurred Lines' at the 2013 MTV Video Music Awards on 25 August with singer Robin Thicke.

That moment became one of the most discussed popular culture events of the year, and one that put twerking on the map. As Miley said afterwards in *Teen Vogue*, March 2018: "Not only was culture changed, but my life and career were changed forever. It inspired me to use my platform for something much bigger. If the world is going to focus on me and what I am doing, then what I am doing should be impactful and it should be great."

Pop Provocateur

Mileyography

1. *Meet Miley Cyrus* (2007)
2. *Breakout* (2008)
3. *Can't Be Tamed* (2010)
4. *Bangerz* (2013)
5. *Miley Cyrus & Her Dead Petz* (2015)
6. *Younger Now* (2017)
7. *Plastic Hearts* (2020)
8. *Endless Summer Vacation* (2023)

Miley Cyrus

Most Played Playlist

Miley has played more than 450 concerts in arenas and stadiums around the world, and even in her own backyard. According to setlist.fm, as of July 2024, these are the songs she's played the most…

216 – 'Party in the USA'
192 – 'See You Again'
149 – 'We Can't Stop'
142 – 'Start All Over'
138 – 'G.N.O. (Girl's Night Out)'
135 – 'The Climb'
130 – 'Wrecking Ball'
122 – 'Can't Be Tamed'
114 – '7 Things'
105 – 'Fly on the Wall'

Pop Provocateur

Grammy Win

When Miley won her first Grammy Award in February 2024, it was the acknowledgement by her peers of 20 years of hard work. It was also, as Miley acknowledged, just an award, and as such Miley took all the acclaim with a degree of humour.

As Miley left the stage with her shiny golden trophy, she couldn't resist adding a bit of saucy charm, as her fans have come to expect. "Thank you all so much! I don't think I forgot anyone… but I might have forgotten underwear. Bye!"

Miley Cyrus

"Everything that I'm doing is supposed to be life and art imitating each other, and so everything has always been honest at that time. When I did 'Party in the USA' that was how I felt. When 'We Can't Stop' came out, I was living that life. It's not like every day I went to the set to act. When it comes to music, I've always been honest."

Miley, *Cosmopolitan*, 26 October 2013

Pop Provocateur

The Last Song

Miley's first and only feature film in a lead role, *The Last Song,* opened to middling reviews in March 2010, though thanks to Miley's presence it was a big enough hit to make a profit. The film's coming-of-age narrative centres around Ronnie (Miley) as a rebellious teen who is forced to spend a summer reconnecting with her estranged father. There, Ronnie finds love with handsome Will (Liam Hemsworth), a volleyball player. While on set, Miley and Liam fell in love for real!

Miley Cyrus

> "Just because I got my tits out before doesn't make me less of a role model."

Miley, *Harper's Bazaar*, 13 July 2017

Pop Provocateur

LGBTQ+

Alongside Ariana Grande, Miley is one of most high-profile and outspoken advocates for the LGBTQ+ community in the US. Since surging away from her Hannah Montana persona, Miley has promoted inclusivity and acceptance for all, and became a queen of the queer community. In 2015, Miley received a prestigious Vanguard Award from the LGBT Center in Los Angeles for her hard work in raising positive awareness.

"A big part of my pride and my identity is being a queer person," Miley said about her sexuality in *Vanity Fair* in February 2019. "In the same way I like to be genderless, I like feeling genre-less."

Miley Cyrus

"I'm in a hetero relationship, but I still am very sexually attracted to women. People become vegetarian for health reasons, but bacon is still fucking good, and I know that."

Miley, *Elle*, 11 July 2019

Pop Provocateur

"I carried some guilt and shame around myself for years because of how much controversy and upset I really caused. Now that I'm an adult, I realize how harshly I was judged."

Miley, *Rolling Stone*, 18 May 2023

Chapter Four
Flower Power

Miley Cyrus

Guardians of the Galaxy

Did you know that Miley became a member of the Marvel Cinematic Universe in 2017 when she voiced a character – she had one line! – named Mainframe during the *Guardians of the Galaxy Vol. 2* end-credit scene. Director James Gunn claimed he wanted Miley for the role after watching her as an advisor on the tenth season of NBC's *The Voice*. "I was watching the show and I thought she's so likable and her voice is awesome, she's got the best voice," Gunn told *Sarah Scoop* (April 2017).

Flower Power

Working Girl

"It was really hard working every day from ages 11 to 18. I didn't get a school escape like most people. I went to work with my dad! That's why like as soon as I turned 18, I was twerking at Juicy J shows. I had just spent ten years every day with my dad and grandma."

The Zach Sang Show, 17 May 2017

Miley Cyrus

Satire Cover Songs

Only once in the history of music has the iconic American satirist "Weird Al" Yankovic covered songs by two members of the same family – The Cyrus's!

Both Miley and her dad, Billy Ray, have had their big hits reimagined by Weird Al. In 2011, there was 'Party in the CIA' (based on Miley's 'Party in the USA') and in 1993 Weird Al parodied Billy Ray's 'Achy Breaky Heart' with 'Achy Breaky Song'.

Naturally, both were huge hits. 'Party in the CIA' now has more than 50 million YouTube views.

Flower Power

Star Collaborations

Miley's so famous, everybody wants to work with her. Over the years, Miley has collaborated with many of the biggest names in music...

'Ashtrays and Heartbreaks', with Snoop Dogg
'Rainbowland', with Dolly Parton
'Doctor (Work It Out)', with Pharrell Williams
'Cattitude', with RuPaul
'Nothing Breaks Like a Heart', with Mark Ronson
'SMS (Bangerz)', with Britney Spears
'Don't Call Me Angel', with Ariana Grande and Lana Del Rey
'Prisoner', with Dua Lipa
'Edge of Midnight', with Stevie Nicks
'Am I Dreaming', with Lil Nas X

Miley Cyrus

Snappy Banter

Everybody knows that Miley is a super-fan of *RuPaul's Drag Race*, the paradigm-shifting, popular culture juggernaut of a TV show. And she proved it beyond all doubt when she appeared on the world's most-seen podcast, *The Joe Rogan Experience*, in September 2020. Miley's clapback to Rogan's complaint about *Drag Race* went viral immediately – and deservedly so. "They all do the same move," Rogan said of the contestants' famous Death Drops. "They just drop down and do the splits." Without missing a beat, Miley replied: "That's what I think when I'm watching your shows, too – all the same stuff." Rogan laughed, and so too did the rest of the world.

Flower Power

Awards

Gracie Awards, 2009: Outstanding Female Lead Comedy Series (*Hannah Montana*)
American Foundation for AIDS Research, 2015: Inspiration Award
Billboard Music Awards, 2014: Best Music Video ('Wrecking Ball')
Billboard Music Awards, 2014: Top Streaming Artist
Billboard Music Awards, 2023: Top Radio Song ('Flowers')
BMI Pop Awards, 2024: Song of the Year ('Flowers')
BRIT Awards, 2024: Best International Song ('Flowers')
Gold Derby Awards, 2002: Best Rock Album (*Plastic Hearts*)
Grammy Awards, 2024: Record of the Year/Song of the Year ('Flowers')
IFPI Awards, 2014: Best Lyrics ('Wrecking Ball')
MTV Europe Music Awards, 2013: Best US Act/Best Video ('Wrecking Ball')
MTV Movie Awards, 2009: Best Song from a Movie ('The Climb')
Variety Awards, 2016: Power of Women Award (Happy Hippie Foundation)

Miley Cyrus

World Tours

Since 2007, Miley has trotted the globe on four world tours: the Best of Both Worlds Tour (2007–08), Wonder World Tour (2009), Gypsy Heart Tour (2011) and Bangerz Tour (2014), as well as two album promotions for Milky Milk Tour (2015, to support the *Dead Petz* album) and the Attention Tour (2022, to support *Plastic Hearts*).

Miley's Bangerz Tour was her largest to date – 78 shows in total – and was a critical and commercial hit, equal to the album's phenomenal worldwide success.

Flower Power

Inspirations

Rumours by Fleetwood Mac is Miley's favourite album ever, released originally in 1977. Today, the album has sold more than 40 million copies and is the ninth biggest-selling album of all time. It features a jaw-dropping collection of hit singles, including 'Go Your Own Way', 'Dreams', 'Don't Stop', 'The Chain' and 'You Make Loving Fun'.

Miley often cites the band's chief singer and songwriter Stevie Nicks as a main source of inspiration and influence.

Miley Cyrus

"I was so embarrassed to be on the red carpet and so many of those fucking disgusting photographers would tell me to blow a kiss, and that's not me! I don't want to blow you a kiss. I didn't know what to do with my face, so I stuck my tongue out, and it became a rebellious, punk-rock thing."

Miley, on her signature tongue pose, *Billboard*, 5 March 2017

Flower Power

Tattoo You

To date, Miley has more than 74 tattoos. Her most famous one, perhaps, was her first. She got it inked when she was just 17 – presumably without her parents' permission!

The tattoo reads "Just Breathe" written on her rib cage, and is a tribute to her best friend Vanessa, who passed away tragically from cystic fibrosis, as well as her two grandfathers who died of lung cancer. "The tattoo reminds me not to take things for granted," Miley told *Harper's Bazaar* in January 2010. "Breathing – that was something none of them could do, the most basic thing. And I put it near my heart, because that is where they will always be."

Miley Cyrus

"Everyone, you're welcome. I took all the slaps for you! Everything that anyone could have been mad at, I've done it all, so nothing seems that bad compared to all the things I've done."

Miley, on being a scapegoat for all of society's problems, *CBS Sunday Morning with Anthony Mason*, 29 October 2017

Flower Power

Sexual Freedom

In an interview with Ramin Setoodeh in *Variety*, on 11 October 2016, Miley revealed to the world that she identified as pansexual, a term used to describe someone who dates all people regardless of gender or sexuality. Miley also revealed she identifies as gender-fluid too. The singer's sexuality caused her family confusion as a young woman where she "grew up in very religious Southern family". Miley claimed that it was hard for her mother, Tish, to understand.

"She didn't want me to be judged and she didn't want me to go to Hell. But she believes in me more than she believes in any God. I just asked for her to accept me. And she has."

Miley Cyrus

Legendary

In August 2024, Miley was awarded the honour, and title, of Disney Legend at the 2024 D23 Expo. Other recipients of this highly prestigious prize included Hollywood superstars Harrison Ford, Jamie Lee Curtis and James Cameron.

Miley, of course, stood out like a sore thumb at the ceremony, though for good reason: she was the youngest recipient in the iconic award's history!

Flower Power

"People were so shocked by some of the things that I did at the VMAs. It should be more shocking that, when I was 11 or 12, I was put in full hair and makeup, a wig, and told what to wear by a group of mostly older men."

Miley, *Harper's Bazaar*, 13 July 2017

Miley Cyrus

Essential Album:
Endless Summer Vacation

Miley's eighth studio album is nothing short of a masterpiece. Arriving with the Grammy award-winning 'Flowers' as its lead single, the record ruled the top spot on the US Billboard chart for six weeks and became the 19th best-selling album of the year. It's also the only album where Miley is credited as songwriter on all 12 tracks, including the hit singles.

'Flowers'
'Jaded'
'Rose Colored Lenses'
'Thousand Miles'
'You'
'Handstand'
'River'
'Violet Chemistry'
'Muddy Feet'
'Wildcard'
'Island'
'Wonder Woman'

"I'm listening to it 20,000 times to make sure it's perfect. I have to make sure every detail is perfect. There are albums that people still are listening to, like Michael Jackson's *Bad*, because it's so fucking dope. I want people to listen to *Bangerz* like that. I want to make sure my record is the best it can be. I'm trying to set a new standard for pop music."

Miley, *Rolling Stone*, 27 September 2013

Miley Cyrus

Billy Ray Cyrus

Miley's dad, Billy Ray, began his musical family empire in 1992 – the year of Miley's birth – and the year he hit the big time with his hit country song 'Achy Breaky Heart'! The accompanying album, *Some Gave All*, sold more than 9 million copies in the USA.

"I was born right when 'Achy Breaky' came out," Miley told *BBC Newsbeat* reporter Ian Youngs in October 2008. "I remember Dad always being on tour. But that was cool for me, it allowed me to be independent and work my way to acting and singing by myself, and not just by following my dad's lead."

Flower Power

Black Mirror

Miley's 2019 episode of the dystopian sci-fi series *Black Mirror* entitled 'Rachel, Jack and Ashley Too' was one of the show's most outstanding from the fifth season of the Netflix original series. Created by Charlie Brooker, the show presented a future of imaginable horrors based on the current realities of modern life. In Miley's episode she portrayed Ashley O, a fictional pop star (and voiced her AI doll, Ashley Too), for which she received critical acclaim for her acting. In an interview in *Elle* on 11 July 2019, she said:

"The character Ashley O is me. They gave me the script and I read it, and I was like, No one else can play character this because this is my life."

Miley Cyrus

Teen Queen Meets the Queen

One unforgettable night in 2009 occurred on 7 December when 17-year-old "teen queen" Miley Cyrus met the real Queen, Her Majesty Queen Elizabeth II at the Royal Variety Performance in Blackpool, Lancashire, in the UK, a celebrated annual British tradition.

Meeting the Queen, Miley wore an orange maxi-dress – with no bra – and showed a little more skin than these conservative shows usually encourage. The Queen didn't seem to care. However, during her performance of 'Party in the USA', Miley made the rest of the Royal Family blush when she began gyrating in leather hot pants!

Flower Power

Debut at No. 1

When Miley released her debut album, 2007's *Meet Miley Cyrus*, she became the youngest solo female singer to ever have a No. 1 album on Billboard 200 chart, beating her Disney predecessor and idol Hilary Duff. Miley was just 14 years old!

Miley Cyrus

"The smartest thing I ever did was to put my debut album on a double disc. I wasn't valued at the time like Hannah was. But the voice behind Hannah was always me."

Miley, *Teen Vogue*, 1 November 2023

Flower Power

The Lure of the Applause

In January 2001, while Billy Ray Cyrus was starring in his TV show *Doc*, which was filmed in Canada, a nine-year-old Miley showed her first interest in acting. To follow this dream, she began attending classes at Canada's celebrated Armstrong Acting Studios. Miley trained there for four years while her family lived in Canada. Miley is not the only famous alumni to get their start at Armstrong.

Other notable stars include Marvel's Simu Liu, Nina Dobrev, Carson MacCormac, Jordan Alexander and Brittany Allen.

Miley Cyrus

"I discredited myself... almost every step of the way. During *Dead Petz*, discrediting *Bangerz*. During *Bangerz*, discrediting *Hannah Montana*. During 'Malibu', discrediting *Bangerz*. It's almost like when I have evolved, I've then become shameful of who I was before. What makes you an adult, I think, is being OK with who you've been before."

Miley, *Rolling Stone*, 4 December 2020